Genres:
Jazz Fusion
Jazz-Rock
Free Jazz
Jazz-Funk
World Music

Best Albums:
Tale Spinnin' (1975)
Heavy Weather (1977)

Classic Lineup:
Joe Zawinul
Wayne Shorter
Jaco Pastorius
Alex Acuna
Manolo Badrena
Alphonso Johnson

Trivia/Facts:
Weather Report was considered a controversial band amongst insiders in the jazz music field.
Weather Report started as an experimental avant-garde jazz group eventually working into a hybrid of jazz and rock called Jazz Fusion
Their music also fused jazz with funk after the inclusion of bassist Jaco Pastorius

Weather Report

Thelonious Monk

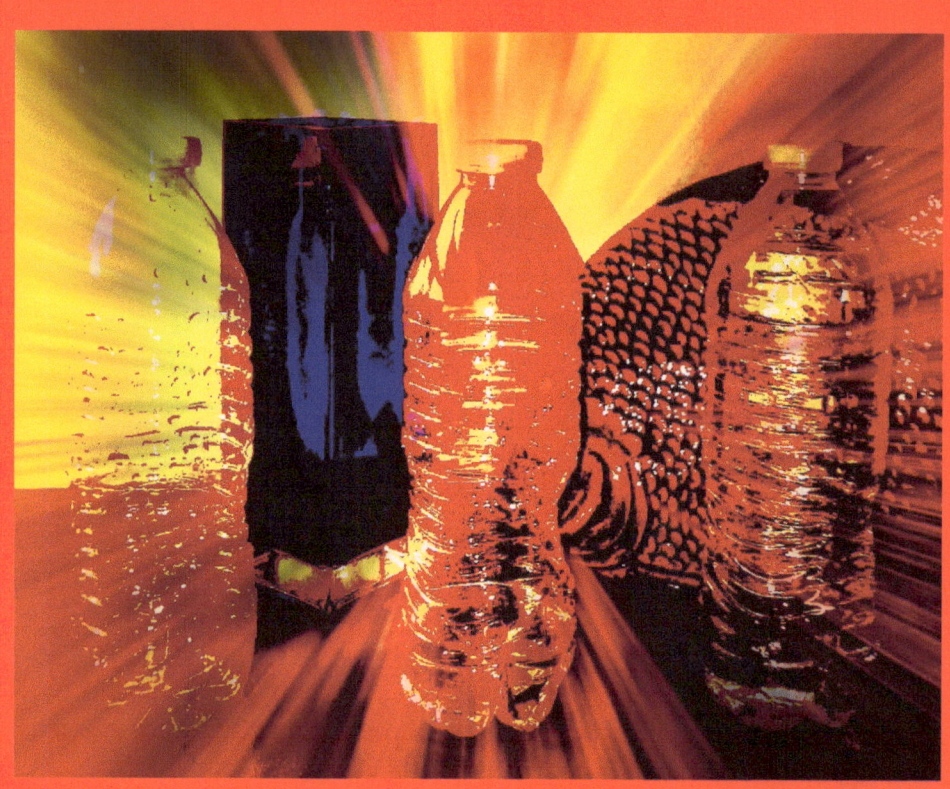

Rick Henry's Jazz Art

Jazz music, to me, is an expression of many shades and emotions. Some are direct and others are obscure. Regardless of how it is executed I am a fan of Jazz.

My initial introduction to jazz music happened in 1981 when I began working in a local music store called Licorice Pizza. One of my co-workers, a head banging heavy metal loving music aficionado was a big fan of jazz. Between playing albums by AC/DC, Black Sabbath, Judas Priest, Metallica, Megadeth, Yngwie Malmsteen and others he would slip in the occasional jazz album. He was strongly drawn to Ornette Coleman. Funny thing is Coleman never caught my ear. As a matter of fact at that time in my life jazz music on the whole did not appeal to me. I was 21 in 1981 and was more into The Cars, Jimi Hendrix, Gary Numan and anything from KROQ.

Fast forward to 1997, always a late bloomer, I had recently purchased my first CD player. Amongst my initial CD purchases was a greatest hits collection by the 70's funk group War (best remembered for their hits "The World Is A Ghetto," "Why Can't We Be Friends," "Low Rider" and others). Along with their popular hits sat a few album tracks that contained a real jazz vibe about them. This made me inspect the band a bit further and I discovered that bandmember Lee Oskar had recorded a few solo albums. I checked out his 1978 album "Before The Rain," and really enjoyed the jazz grooves included with in. From there I decided that I wanted to dig further into the jazz genre of music. The first name that popped into my head was Ornette Coleman. I started with Coleman's 1959 album "The Shape of Jazz To Come" and from there it snowballed. Now, I own several titles by Ornette Coleman.

But my love for jazz did not stop with Ornette Coleman. In the next few years my collection of jazz music flourished. By the year 2000 I was collecting and searching for jazz music with fervor. Jazz is now one of the biggest genre blocs in my collection.

Twenty years later I am assembling this book called "Rick Henry's Jazz Art." The collection of artwork in this book was created from photos I've taken and pictures I've drawn. Each photo and picture was transferred to my computer, which from there I put each image through three or four photo editors and applied different effects and added angles, shadows and other oddities to turn each image into a unique work of art.

Each image reflects the feelings and emotions I get from listening to the music of this collection of talented jazz musicians. In order to give more insight and depth to each image I added a bit of common knowledge background information about each musician.

There are many of my favorite jazz musicians that are not represented here therefore most likely there will be a second volume of Rick Henry's Jazz Art.

Weather Report

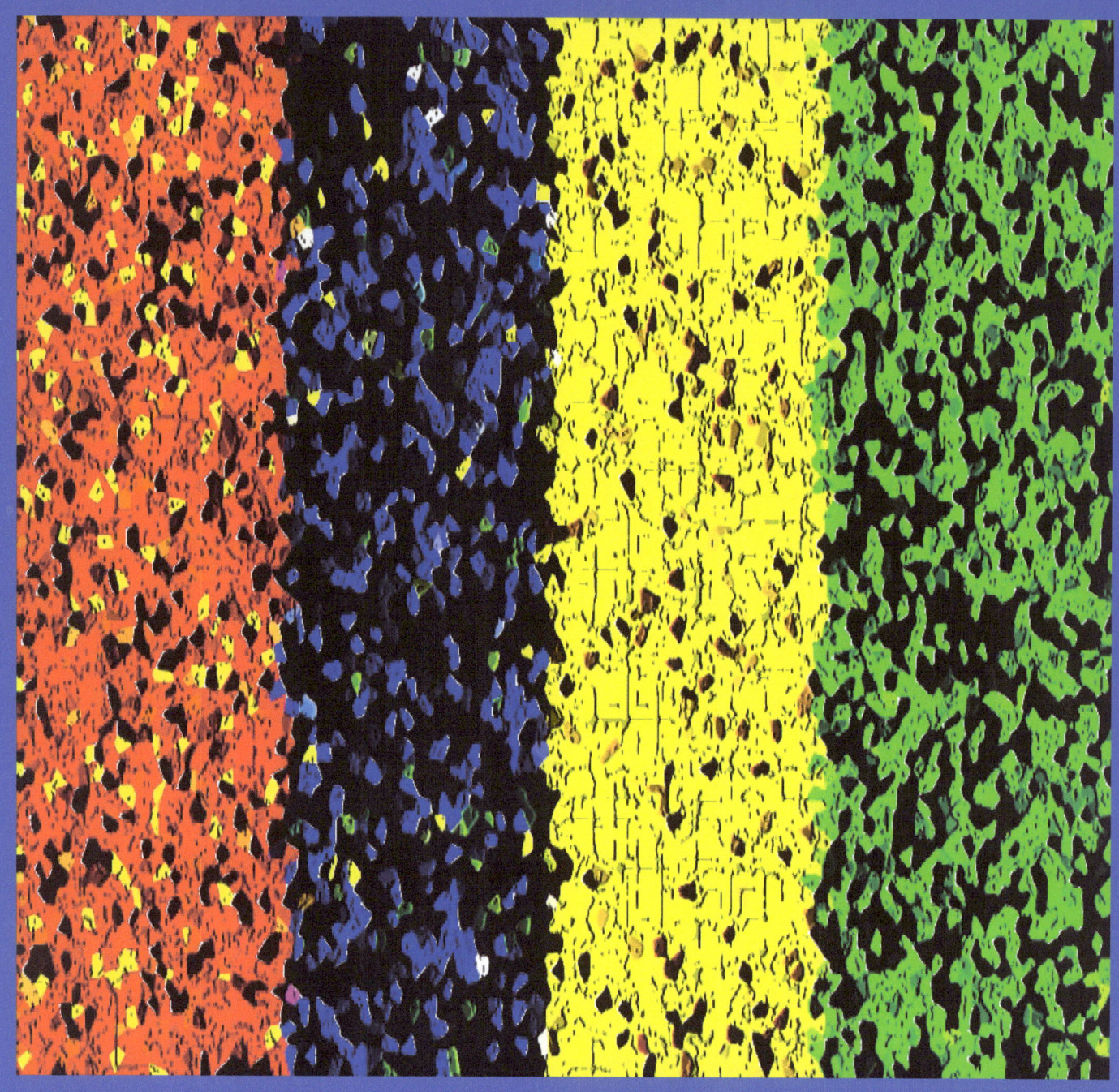

Genres:
Bebop
Hard Bop
Cool Jazz

Prime Instrument:
Piano

Best Albums:
Monk's Music (1957)
Monk's Dream (1963)
Criss-Cross (1963)
Straight No Chaser (1967)
Underground Monk (1968)

Collaborating Musicians:
Art Blakely
Miles David
Milt Jackson

Trivia/Facts:
Composed jazz standard "Round Midnight" in 1944
Known for his unique taste in suits, hats and sunglasses
His middle name is Sphere, which was his maternal grandmother's name Sphere Batts
His birth certificate lists his middle name as Junior
Monk is one of the earliest innovators of the bebop genre

Thelonious Monk

Twin Danger

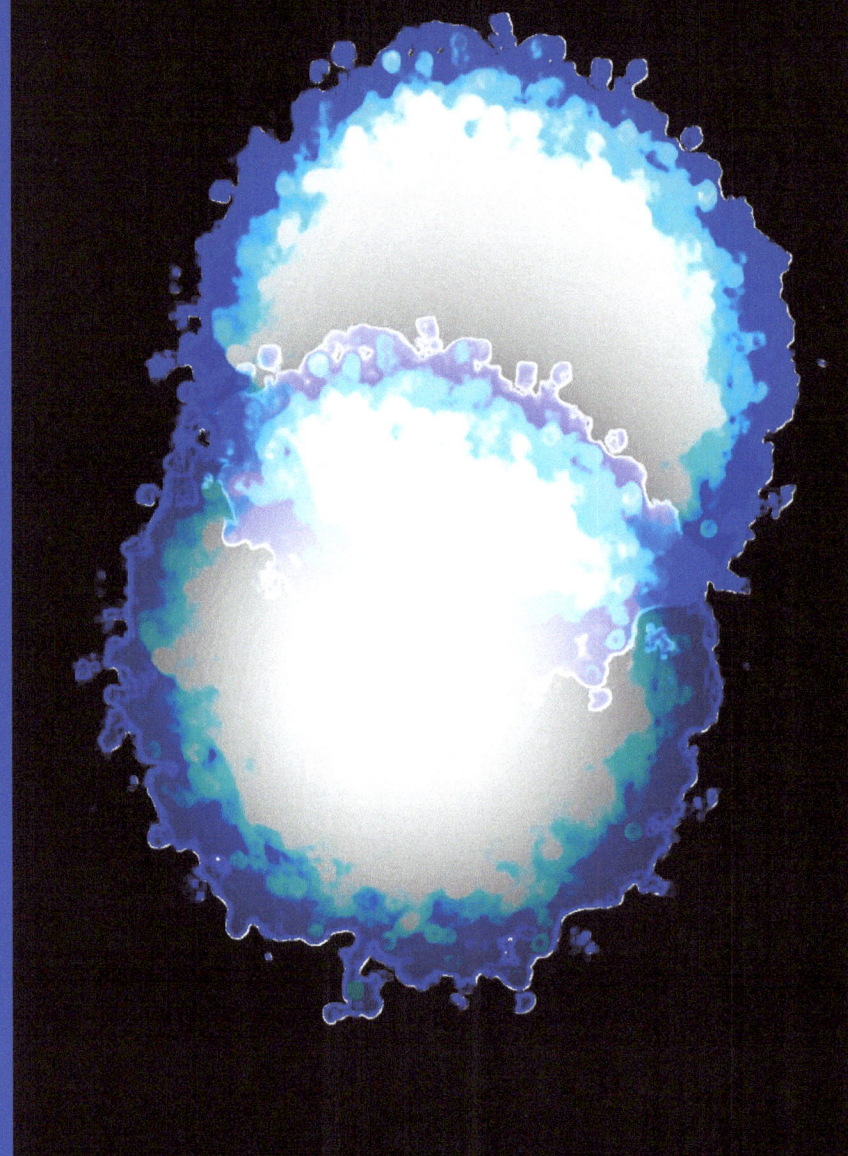

Genres:
Downtempo
Chill-out
Cocktail jazz
Cool jazz
Smooth jazz
Blues
Lounge
Noir jazz
Dark jazz
Crimejazz

Album:
"Twin Danger" (2015)
at this point in time Twin Danger has released only one album

Band Members:
Vanessa Bley
Stuart Matthewman

Trivia/Facts:
Vanessa Bley is the daughter of jazz pianist Paul Bley, known for his contributions to the free jazz movement of the 1960's.
Stuart Matthewman is best known as the guitarist and saxophonist for Sade

Twin Danger

Vijay Iyer

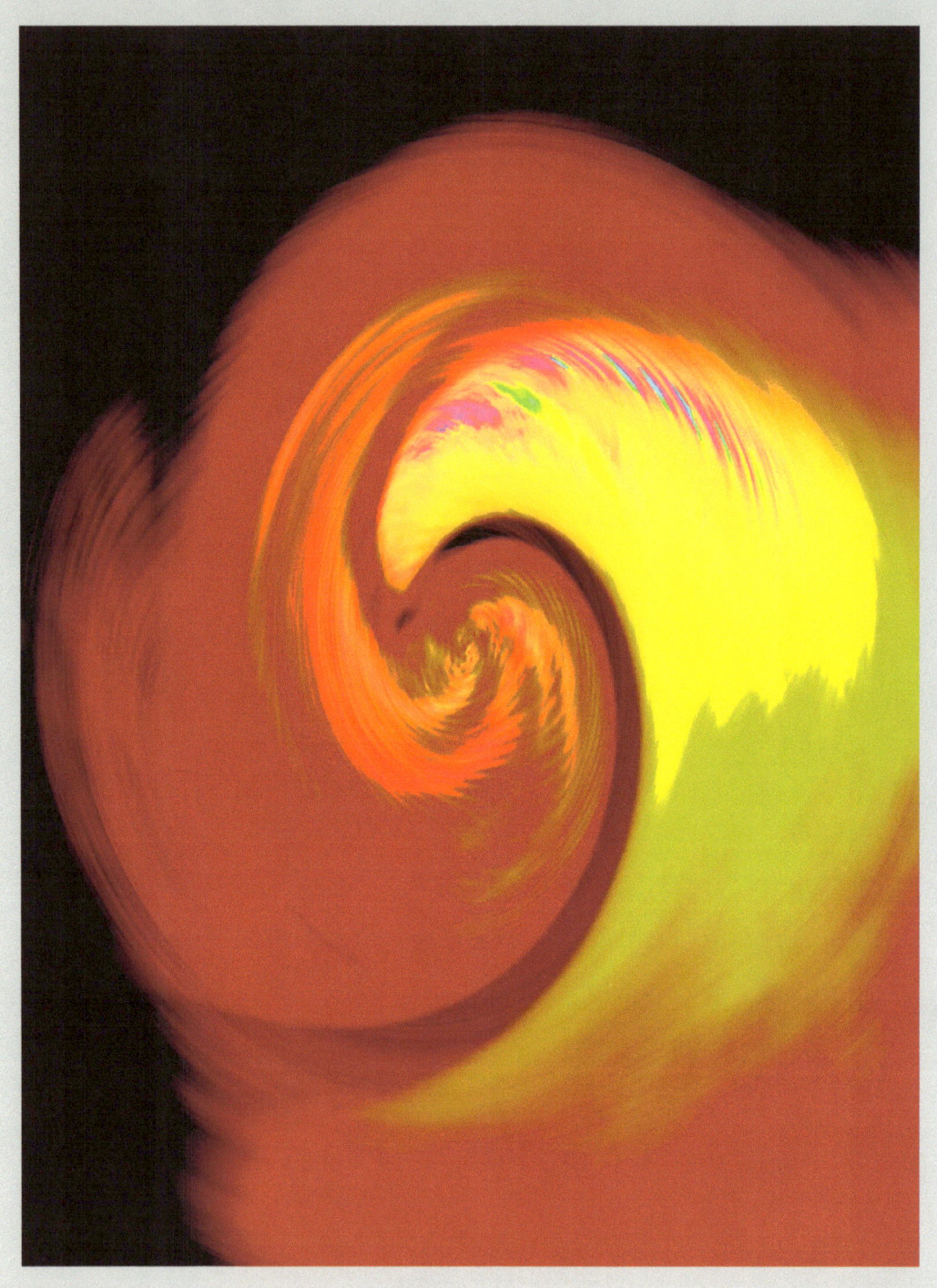

Genres:
Progressive Jazz
Jazz Piano
Jazz Fusion
World Fusion
M-Base

Best Albums:
Historicity (2009)
Accelerando (2012)
Break Stuff (2015)

Collaborating Musicians:
Prasanna and Nitin Mitta
Wadada Leo Smith
Mike Ladd
Steve Coleman
Burnt Sugar

Trivia/Facts:
Vijay was born in Albany, New York and is the son of Sri Lankan immigrants to the US
He studied classical violin for fifteen years beginning at the age of three and plays piano by ear
Vijay attended both Yale University and UC Berkeley and has undergraduate degrees in mathematics and physics
In 2003 Vijay won the Herb Alpert Award in the Arts for his musical contributions
The 2009 album "Historicity" was nominated for the Best Instrumental Jazz Album Grammy
Downbeat Magazine named Vijay Iyer 2015 Artist of the Year and 2014 Pianist of the Year

Vijay Iyer

Ornette Coleman

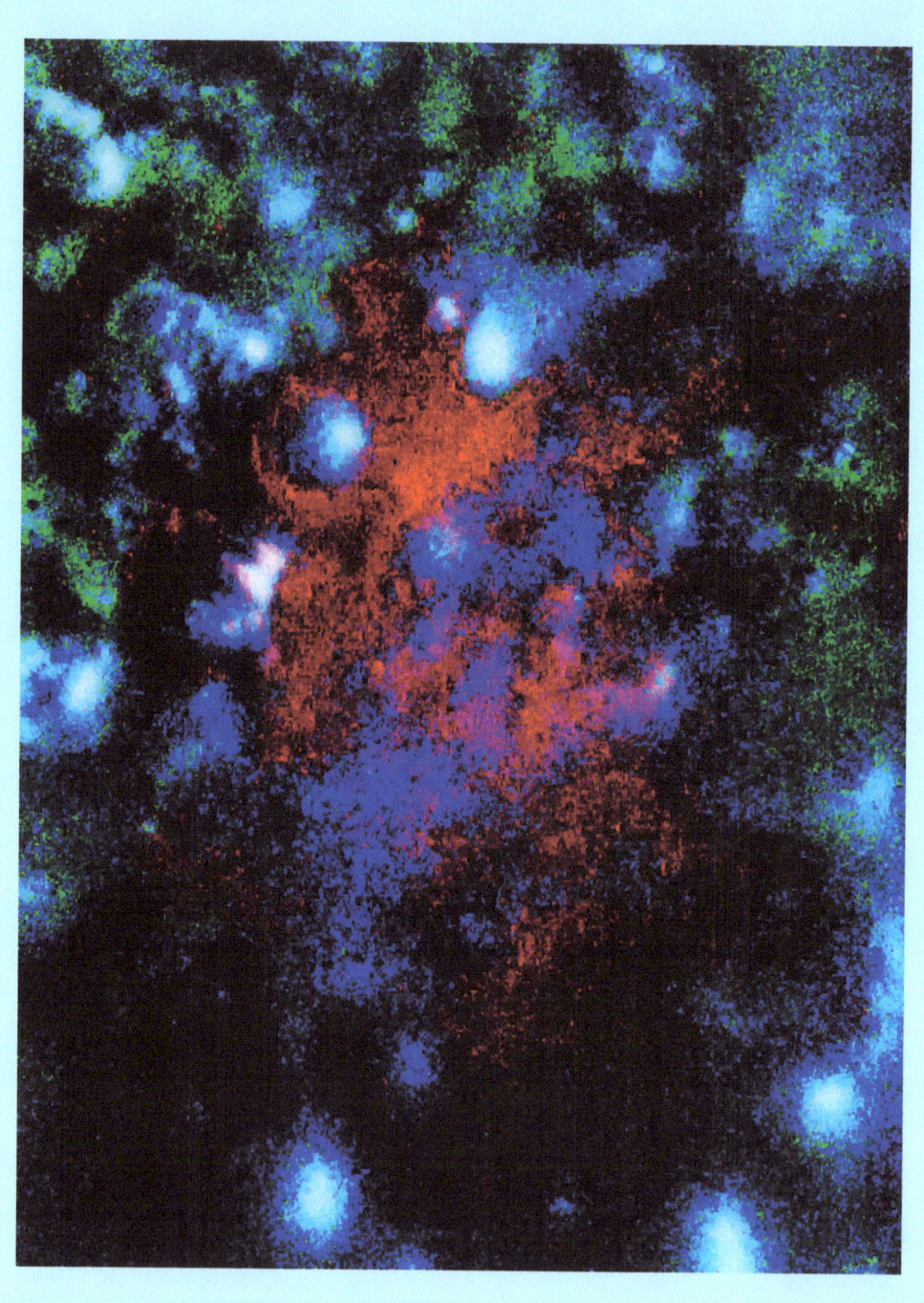

Genres:
Avant-garde jazz
Free jazz
Jazz-rock
Free funk
Modern Creative

Prime Instruments:
Saxophone
Violin
Trumpet

Best Albums:
The Shape Of Jazz To Come (1959)
Change of the Century (1960)
Free Jazz (1961)
Science Fiction (1971)
Song X (1986)
Virgin Beauty (1988)
Tone Dialing (1995)
Sound Grammar (2006)

Collaborating Musicians:
Pat Metheny
Jack DeJohnette
Charlie Haden
Paul Bley
Denardo Coleman
Eric Dolphy

Trivia/Facts:
The 1986 album "Song X" is a highly regarded collaboration album comprising of
Ornette Coleman, Pat Metheny, Jack DeJohnette, Charlie Haden and Coleman's son Denardo Coleman
While developing a career in music, Coleman worked various jobs including an elevator operator
Grateful Dead leader, Jerry Garcia played guitar on three tracks from Coleman's 1988 "Virgin Beauty"
Coleman received a Lifetime Achievement Grammy Award in February 2007
His 2007 album "Sound Grammar" won a Pulitzer Prize in music
Coleman received an Honorary Doctor of Music degree in 2010 from the University of Michigan.
During the same presentation US President, Barack Obama, received an Honorary Doctor of Law degree

Ornette Coleman

Michael Franks

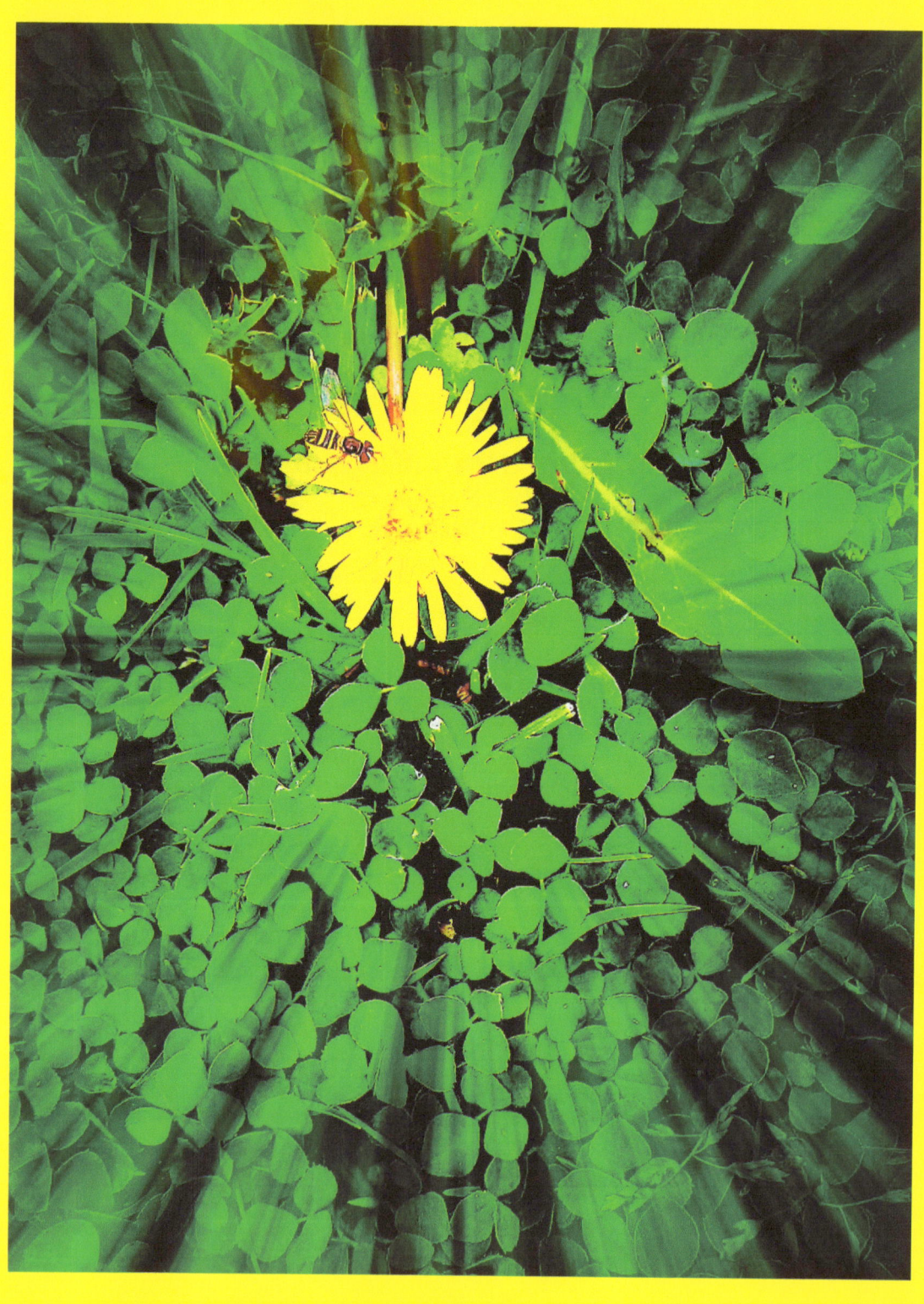

Genres:
Smooth jazz
Jazz pop
Crossover jazz

Hit Singles:
Popsicle Toes (1976)
Your Secret's Safe With Me (1985)
Island Life (1987)
Now That Summer's Here (2011)

Best Albums:
The Art of Tea (1976)
Sleeping Gypsy (1977)
Tiger In The Rain (1979)
Object Of Desire (1982)
Skin Dive (1985)
Blue Pacific (1990)
Time Together (2011)

Trivia/Facts:
At the age of 14 Michael bought himself a Japanese Marco Polo guitar, which came with six private lessons. These were the only music lessons he had in his life.
His album The Art of Tea features jazz legends Joe Sample, Larry Carlton and Wilton Felder
Michael Franks' songs have been recorded by a variety of musical acts including Lyle Lovett, Diana Krall, Ringo Starr, Carpenters, The Manhattan Transfer, Patti Labelle and others
Popsicle Toes is his best-known song

Michael Franks

Ella Fitzgerald

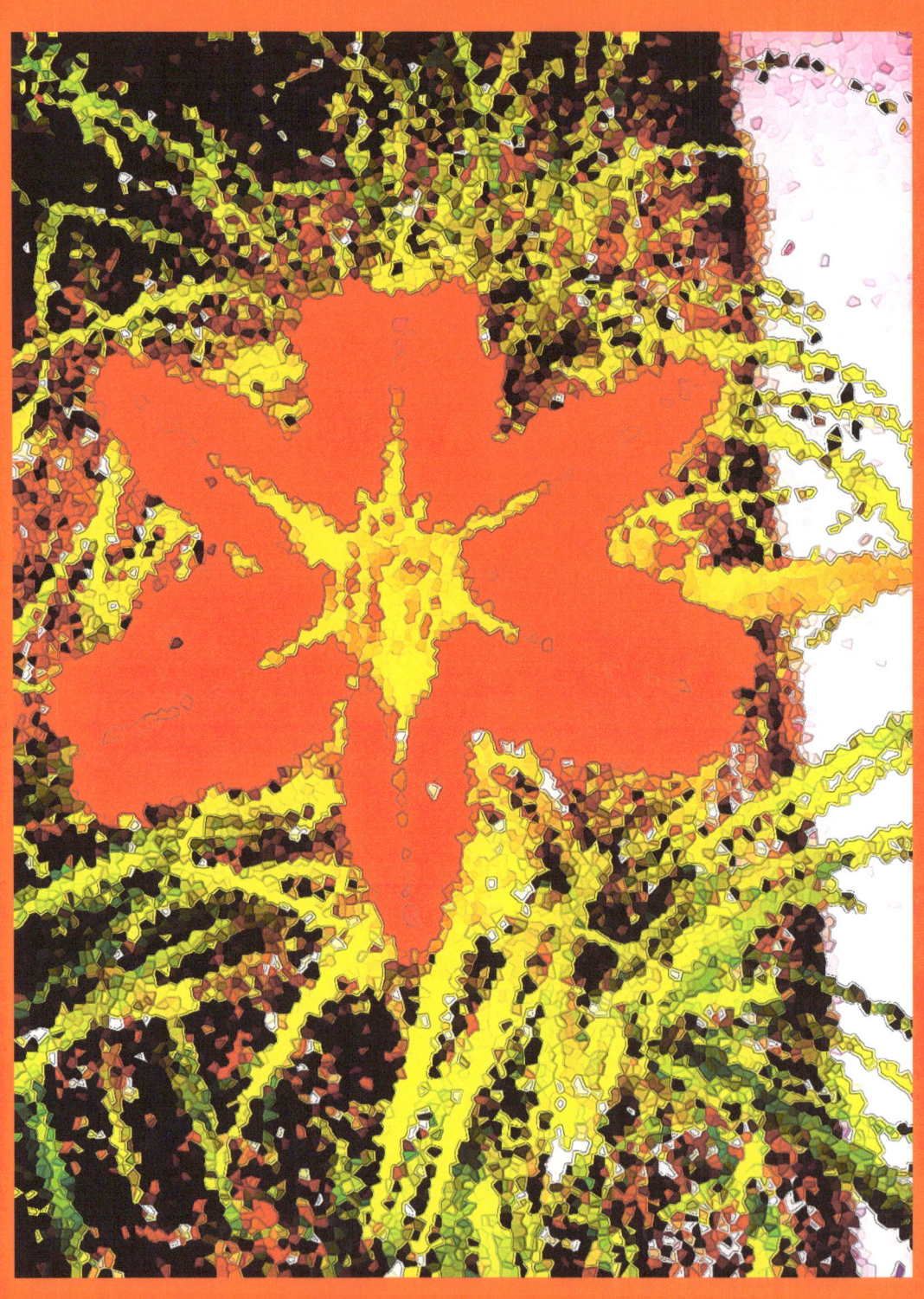

Genres:
Swing
Bebop
Traditional pop
Vocal jazz
Blues

Notable Albums:
Ella Fitzgerald Sings The Cole Porter Songbook (1956)
Ella Fitzgerald Sings the Duke Ellington Songbook (1957)
Ella Swings Lightly (1958)
Ella Fitzgerald Sings the Irving Berlin Songbook (1958)
Ella Fitzgerald Sings the George and Ira Gershwin Songbook (1959)
Ella In Berlin: Mack The Knife (Live)(1960)
Fine and Mellow (recorded in 1974 released 1979)
Fitzgerald and Pass… Again (1976)
The Best Is yet To Come (1982)
All That Jazz (1989)

Collaborators:
Chick Webb
Duke Ellington
Count Basie
Louie Armstrong
Joe Pass
Oscar Peterson
Andre Previn

Nicknames:
The First Lady of Song
Queen of Jazz
Lady Ella

Trivia/Facts:
Noted for her purity of tone, precise diction, phrasing, intonation and improvisational ability
Ella had four singles reach #1 in the US including "A-Tisket A-Tasket" in 1938
Ella won a total of 14 Grammy Awards including a Lifetime Achievement Award in 1967
Ella wrote lyrics (or partial lyrics) on several of her hit songs such as "A-Tisket A-Tasket," "Chew, Chew, Chew (Your Bubblegum)," "I Found My Yellow Basket" and several others
Ella wrote lyrics to Quincy Jones' "Sanford and Son" theme song. Her recorded version is also known as "The Streetbeater" and is featured on her 1972 album "Jazz at Santa Monica Civic '72"

Ella Fitzgerald

Stefon Harris

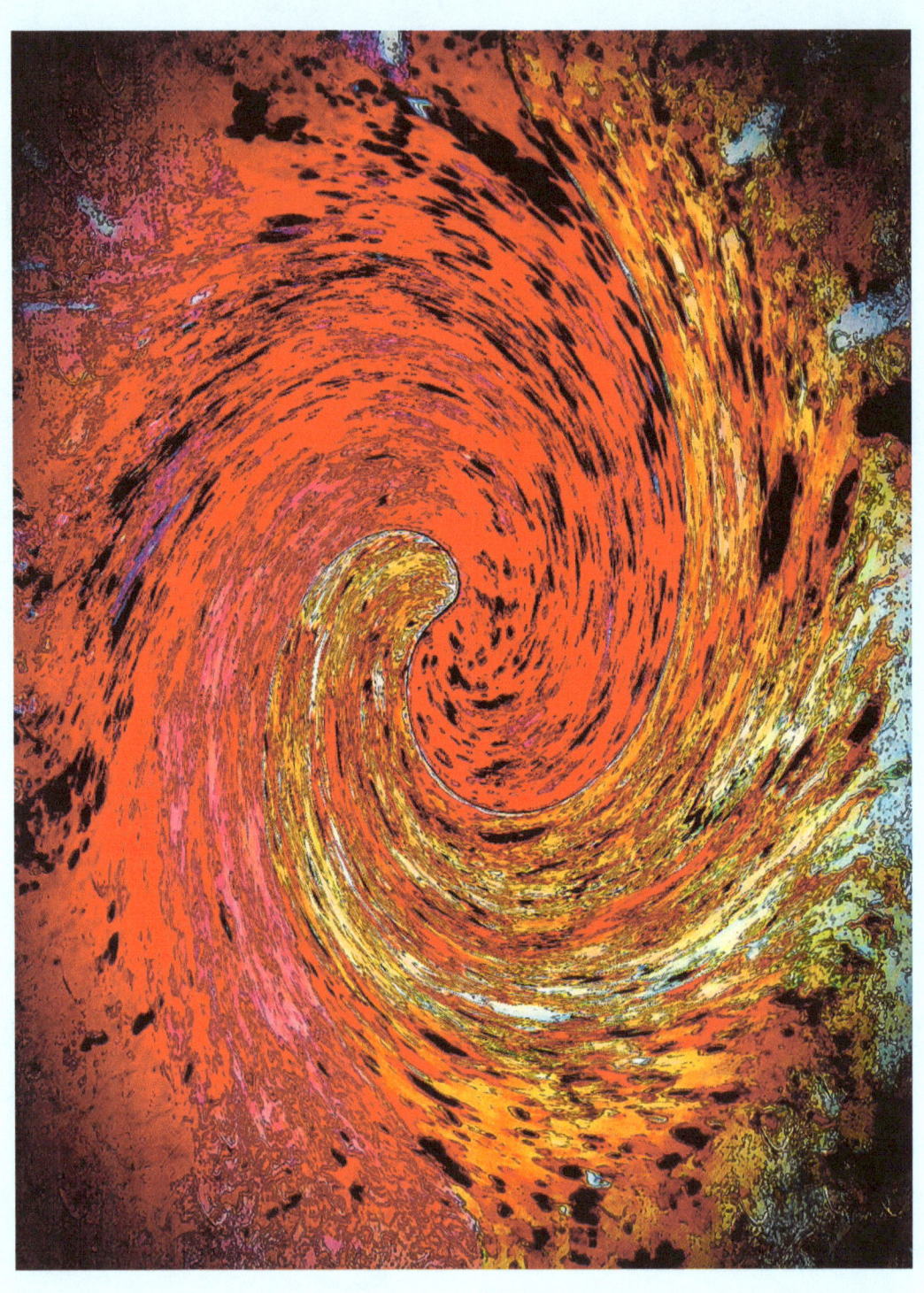

Genres:
Post-bop
Hard-bop
Straight Ahead Jazz
Progressive Jazz
Contemporary Jazz

Highlighted Albums:
A Cloud Of Red Dust (1998)
Black Action Figure (1999)
The Grand Unification Theory (2003)
Urbanus (2009)
Ninety Miles (2011)

Primary Instruments:
Vibraphone
Marimba

Collaborators:
Charlie Hunter
David Sanchez
Christian Scott
Joe Henderson
Diana Krall
Joshua Redman
Cassandra Wilson

Trivia/Facts:
In a 1999 review, The Los Angeles Times hailed Stefon Harris as "one of the most important young artists in jazz"
Charlie Parker is his earliest influence in jazz music
Harris has earned four Grammy Award nominations during his career including Best Jazz Album for "Kindred" (2001) and "Grand Unification Theory" (2003), Best Jazz Instrumental Solo for "Black Action Figure" (1999) and Best Contemporary Jazz Album for "Urbanus" (2009)

Stefon Harris

Jaco Pastorius

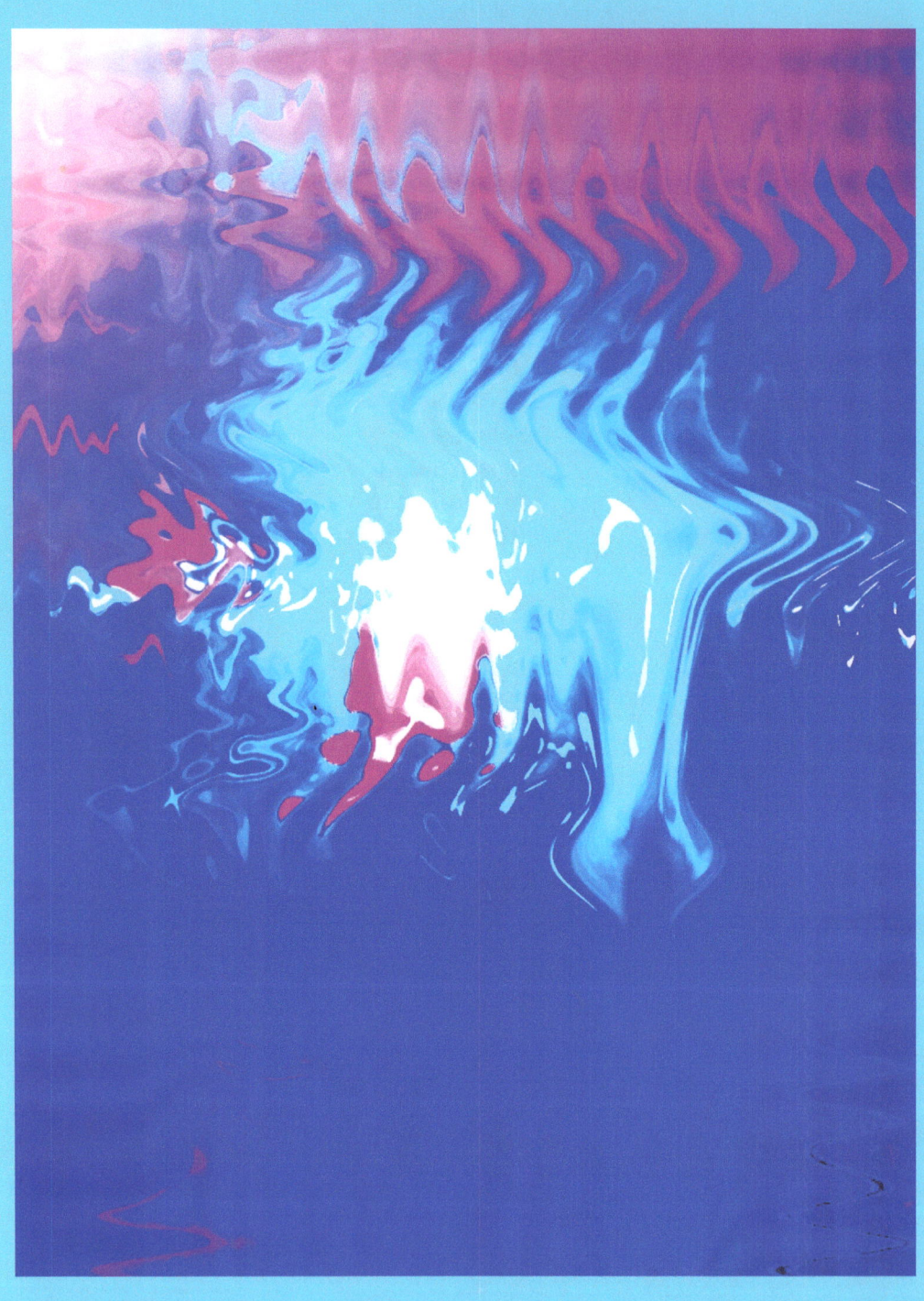

Genres:
Jazz Fusion
Jazz Funk
Post Bop
Progressive Jazz

Highlighted Albums:
Jaco Pastorius (1976)
Word Of Mouth (1981)
Invitation (1983)

Primary Instruments:
Bass Guitar
Double Bass
Drums
Piano

Collaborators:
Weather Report
Herbie Hancock
Pat Metheny
Joni Mitchell
Paul Bley
Bruce Ditmas
Ian Hunter

Trivia/Facts:
Jaco Pastorius' first major record label break came in 1975 when Blood, Sweat and Tears drummer Columbia Records sent Bobby Colomby out to discover new talent for their jazz division.
Jaco joined Weather Report in 1975 as the bass player and eventually adding drums. He left the band in 1982
He performed on four Joni Mitchell albums including "Hejira" (1976), "Don Juan's Reckless Daughter" (1977), "Mingus" (1979) and "Shadows and Light" (1982)
Jaco Pastorius died on September 21, 1987 at the age of 35. His death stemmed from injuries incurred from a brawl he had ten days earlier with a bouncer who denied Jaco entrance to the Midnight Bottle Club in Wilton Manors, Florida.

Jaco Pastorius

Charles Mingus

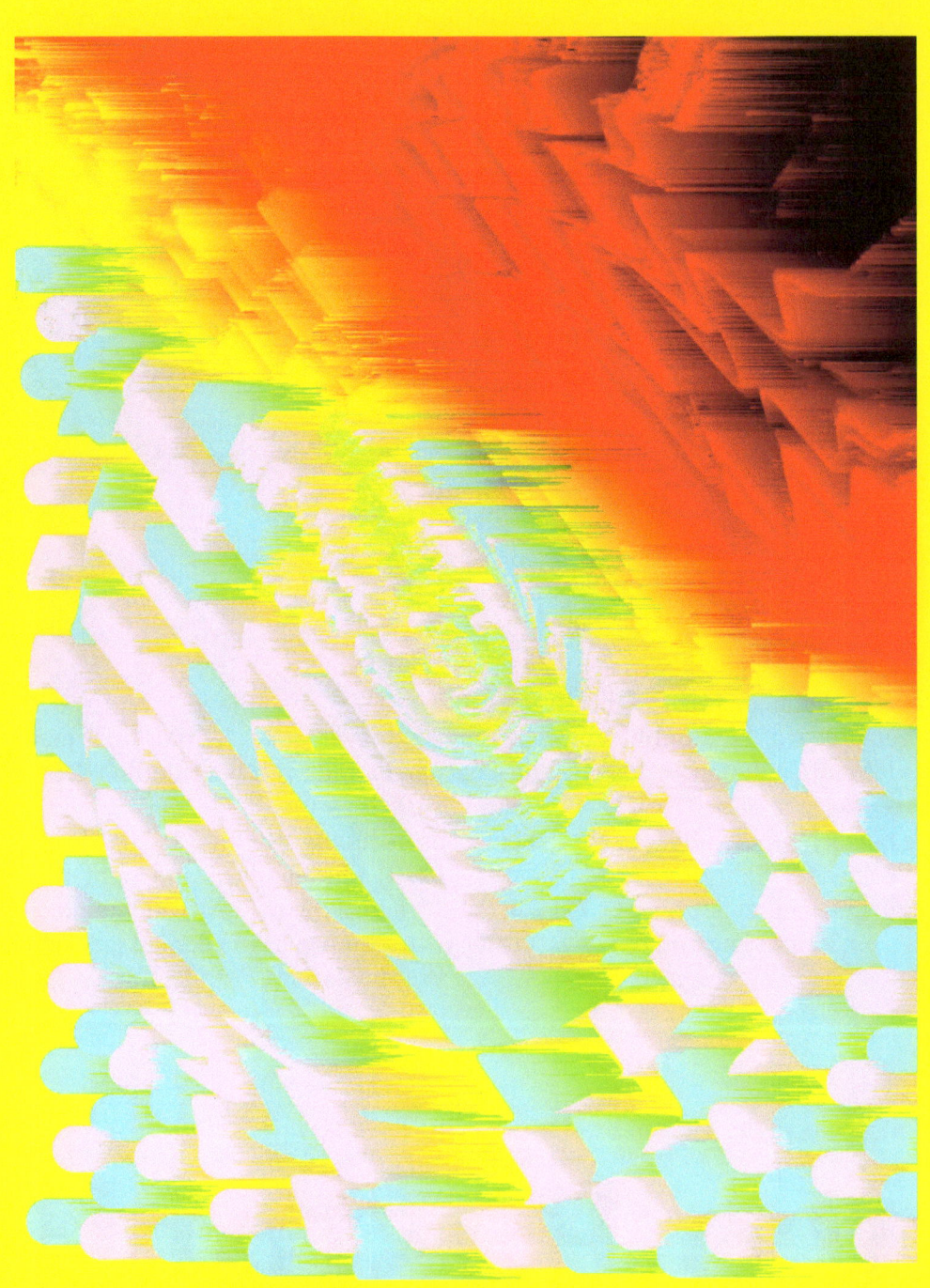

Genres:
Hard Bop
Bebop
Avant-garde jazz
Post-bop
Orchestral jazz
Free jazz
Progressive jazz

Primary Instrument:
Double bass
Piano
Cello

Highlighted Albums:
Pithecanthropus Erectus (1956)
The Clown (1957)
Mingus Ah Um (1959)
Mingus Dynasty (1959)
Mingus (1960)

Collaborators:
Miles Davis
Eric Dolphy
Duke Ellington
Charlie Parker
Max Roach
Dinah Washington
Lionel Hampton
Bud Powell
Paul Bley

Nicknames:
The Angry Man of Jazz

Trivia/Facts:
Mingus is a pioneer in the development of the double bass technique
He was known for assembling unconventional instrumental configurations for his compositions
Mingus' ambition and demanding temper garnered him the nickname "The Angry Man of Jazz"
He was known to have stopped concerts to scold inattentive audiences or less than perfect concert musicians. He has also been known to fire a musician on stage during a concert
Mingus is considered the greatest jazz bassist in music history and he is the only bassist that has been strong enough and proficient in his musicianship to bring the bass to the forefront of a band.

Charles Mingus

Henry Threadgill

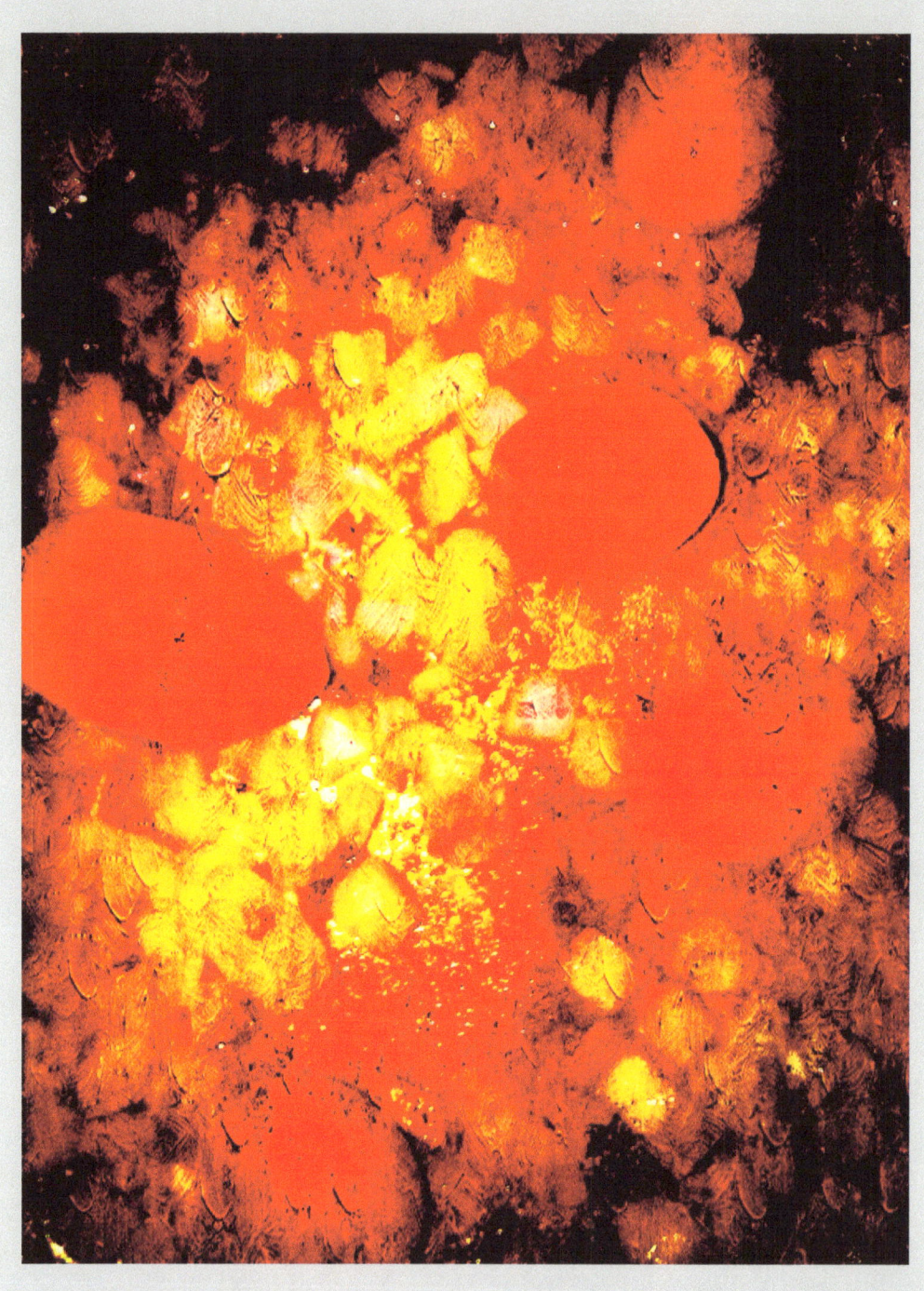

Genres:
Avant-garde jazz
Modern Creative Jazz

Primary Instruments:
Saxophone (alto)
Flute

Highlighted Albums:
Too Much Sugar For A Dime (1983)
You Know The Number (1987)
Easily Slip Into Another World (1988)
Carry The Day (1994)
In For A Penny, In For A Pound (2015)
Odd Locks and Irregular Verbs (2016)

Collaborators:
Bill Laswell
Sly and Robbie
Wadada Leo Smith
Jack DeJohnette
Very Very Circus
Air
Zooid
Ensemble Double Up

Trivia/Facts:
Threadgill's style has been described as complex, ambitious, eccentric and intense
He won the 2016 Pulitzer Prize in music for his composition of "In For A Penny, In For A Pound"

Henry Threadgill

Lenny White

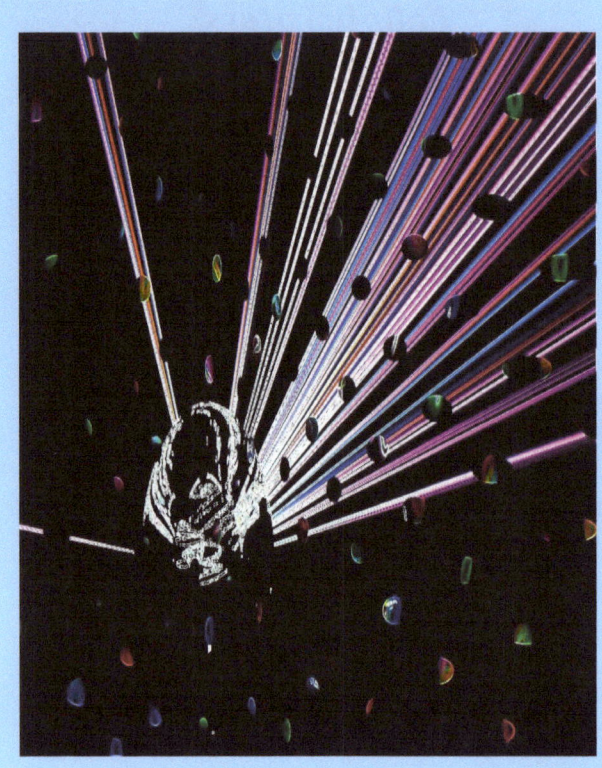

Genres:
Jazz fusion
Jazz funk
Neo bop
Post bop

Primary Instrument:
Drums

Highlighted Albums:
Venusian Summer (1976)
Big City (1977)
The Adventures of Astral Pirates (1978)
Streamline (1978)
Present Tense (1995)

Collaborators:
Return To Forever
Azteca
Jamaican Boys
Twennynine
Miles Davis
Jaco Pastorius
Gato Barbieri
Stanley Clark
Al Di Meola
Chaka Khan
Freddie Hubbard
Joe Henderson
Chick Corea

Trivia/Facts:
Lenny White is best known for being the drummer of Chick Corea's progressive jazz fusion band Return To Forever
Has been named one of the founding fathers of jazz fusion
Lenny's first appearance on record was as drummer on Joe Henderson's 1970 album "If You're Not Part of the Solution, You're Part of the Problem"
His first actual professional recording experience was on Andrew Hill's 1970 album "Passing Ships," which was not released until 2003
White has appeared on legendary jazz albums such as Miles Davis' Bitches Brew from 1970 and Jaco Pastorius' eponymously named album from 1976
Lenny White is a self-taught drummer

Lenny White

Louis Armstrong

Genres:
Dixieland
New Orleans Jazz
Swing
Traditional pop

Highlighted Albums:
Satch Plays Fats: A Tribute to the Immortal Fats Waller (1954)
Ella & Louis (1956)
Louis Meets Oscar Peterson (1957)
Hello, Dolly! (1964)
What A Wonderful World (1970)

Collaborators:
Ella Fitzgerald
Clarence Williams
Lionel Hampton
Jack Teagarden
Earl "Fatha" Hines
Tyree Glenn
Duke Ellington
Dave Brubeck
Mills Brothers

Nicknames:
Dipper
Satchmo
Pops

Trivia/Facts:
Armstrong often said that he was born on July 4, 1900; in the mid 1980s researcher, Tad Jones, found his actual birthday of August 4, 1901 in his baptismal records.
On March 19, 1918 Louis married Daisy Parker, a prostitute from Louisiana, they divorced in 1923.
The nickname Satchmo is short for Satchelmouth most likely given to him for his penchant for telling stories of his life both real and imagined
Armstrong received the nickname Pops due to the fact that he would often forget people's names and instead would call them "pops"
Armstrong won the 1964 Best Male Vocal Performance Grammy Award for his performance of "Hello, Dolly." He was awarded a Grammy Lifetime Achievement Award in 1972

Louis Armstrong

Hermann Szobel

Genres:
Jazz Fusion
Classical Jazz
Progressive Jazz

Highlighted Album:
"Szobel" (1976)
(Hermann Szobel released only one album in his lifetime)

Collaborators:
David Samuels (Spyro Gyra)
Vadim Vyadro

Trivia/Facts:
Hermann Szobel was born in Vienna, Austria in 1958.
During a 1975 recording of Roberta Flack's album, "Feel Like Making Love," Hermann Szobel burst into the studio and shouted, "I am the greatest piano player ever and everyone should listen." They agreed to listen and shortly after Szobel was signed to Arista Records.
Hermann Szobel was only 18 years old when his one and only album was released. Three years after his first album he was set to record a second album but turned away from it all and was never seen again.

Hermann Szobel

Sade

Genres:
Smooth Jazz
Sophisti-pop
Quiet Strom
Soul

Highlighted Albums:
"Diamond Life" (1984)
"Promise" (1985)
"Stronger Than Pride" (1988)

Collaborators:
Stuart Matthewman (also with the band Twin Danger)
Tony Momrelle

Facts/Trivia:
Five of Sade's six studio albums have been certified triple or quadruple platinum, her sixth album "Soldier of Love" has been certified single platinum.
Sade has received nine Grammy Award nominations and has won four, including Best New Artist of 1985.
Sade has one child, a daughter named Mickailia, born in 1995.
Sade made her acting debut in the 1986 film "Absolute Beginners," in which her song "Killer Blow" appeared. David Bowie also made an appearance in the same film.
Before becoming a singer Sade worked as a model and completed a three year course in fashion design.
Sade has sold more than 50 million units worldwide.

Sade

Jack McDuff

Genres:
Hard bop
Jazz funk
Soul jazz

Highlighted Albums:
Hot Barbecue (1965)
A Change Is Gonna Come (1966)
Tobacco Road (1967)
Do It Now (1967)
Down Home Style (1969)

Primary Instrument:
Organ

Collaborators:
George Benson
Red Holloway
Kenny Burrell
Hank Crawford
Willis Jackson
Carmen McRae

Nickname:
Brother Jack McDuff
Captain Jack McDuff

Trivia/Facts:
Jack McDuff gave George Benson his first big break when he hired him to play in his band. Benson first appeared on McDuff's 1963 album "Brother Jack McDuff Live!"
Jack McDuff appeared on George Benson's debut album
"The New Boss Guitar of George Benson" released in 1964.
George Benson stayed with Jack McDuff through 1965 then ventured off
to pursue his solo career.
McDuff toured Japan in the year 2000 at the age of 73.
Jack McDuff released 53 studio and live albums throughout his career.

Jack McDuff

Medeski, Martin & Wood

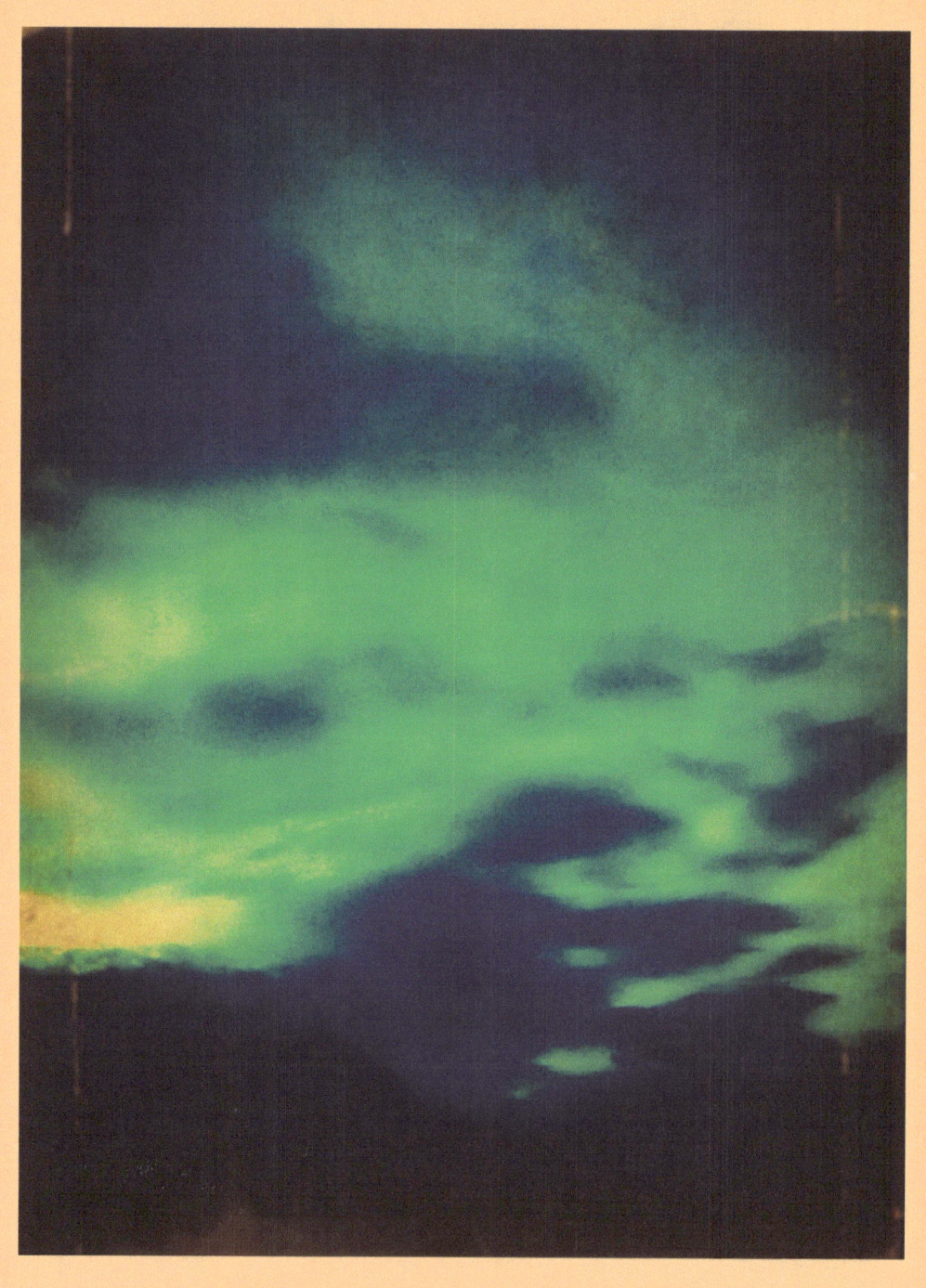

Genres:
Jazz Funk
Jazz Fusion
Electric Jazz
Acid Jazz
Soul Jazz
Avant Jazz
Post-Bop

Highlighted Albums:
Shack-man (1996)
Combustication (1998)
Tonic (2000)
The Dropper (2000)
Uninvisible (2002)
Out Louder (2006)

Collaborators:
John Scofield
Robert Randolph
Nels Cline

Trivia/Facts:
Medeski, Martin & Wood's first gig together was at The Village Gate, a jazz club in Greenwich Village, New York.
MMW started as an acoustic group accompanied by keyboardist, John Medeski's Hammond organ.
MMW performed with rock band Phish in October 1995.

Medeski, Martin & Wood

Eric Dolphy

Genres:
Avant-garde jazz
Free jazz
Post bop
Third Stream

Highlighted Albums:
Outward Bound (1960)
Out There (1960)
Far Cry (1962)
Out To Lunch (1962)

Primary Instruments:
Saxophone
Flute
Clarinet
Piccolo

Collaborators:
Charles Mingus
John Coltrane
Ornette Coleman
Max Roach
Freddie Hubbard

Trivia/Facts:
Eric was known for his unconventional musical techniques along with long intervals between pitches which often times would give his music human and animal like sounds.

Eric Dolphy was born in Los Angeles, California in 1928 and began playing clarinet at the age of six.

Eric Dolphy met Charles Mingus growing up in Los Angeles. The two teamed up in 1959 when Dolphy moved to New York. Dolphy appeared on five of Mingus' studio albums released in 1960.

Eric Dolphy died in 1964 at the age of 36 (only four months after the release of his classic album "Out To Lunch"). He died after he was given an injection of insulin. He experienced insulin shock and went into a diabetic coma.

Upon Eric Dolphy's death, Charles Mingus said, "Usually, when a man dies, you remember—or you say you remember—only the good things about him. With Eric, that's all you could remember. I don't remember any drags he did to anybody. The man was absolutely without a need to hurt".

Eric Dolphy

Quincy Jones

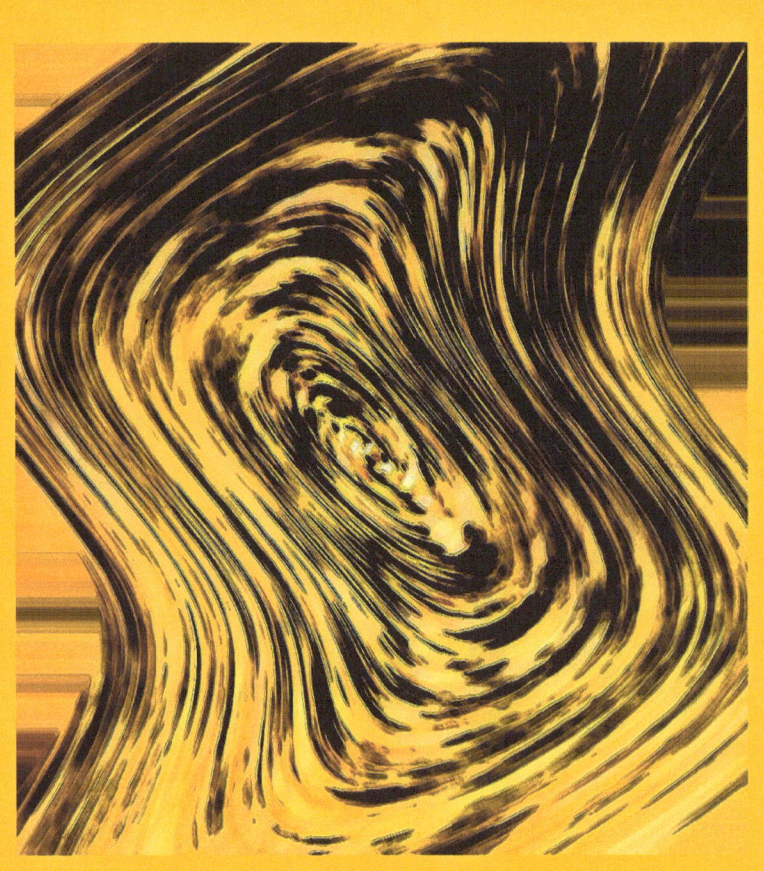

Genres:
Swing
Bossa Nova
Crossover Jazz
Jazz-Pop
R&B
Funk
Soul

Highlighted Albums:
The Birth of a Band (1959)
Walking In Space (1969)
Gula Matari (1970)
Smackwater Jack (1971)
Body Heat (1974)
Mellow Madness (1975)
Sounds… And Stuff Like That (1978)
The Dude (1981)
Back On The Block (1989)
Q's Jook Joint (1995)

Collaborators:
Lionel Hampton
Dizzie Gillespie
Ray Charles
Sarah Vaughan
Dinah Washington
Leslie Gore
The Brothers Johnson
Rod Temperton

Trivia/Facts:
At the age of 14 (1947) Quincy introduced himself to 16-year-old Ray Charles who was playing at the Black Elk Club in Seattle, Washington.
Qunicy, at age 19, traveled to Europe with Lionel Hampton.
He produced Leslie Gore from 1963-1965, their association brought about the hits; "It's My Party," "Judy's Turn To Cry," "She's A Fool" and "You Don't Own Me."
Quincy composed the "Sanford and Son" theme song.
Quincy Jones produced three albums for Michael Jackson; "Off The Wall," "Thriller" and "Bad."
Quincy Jones' 1981 album "The Dude" featured three hit singles: "Ai No Corrida," "Just Once" and "One Hundred Ways."
In total Quincy has won 28 Grammy Awards.

Quincy Jones

BADBADNOTGOOD

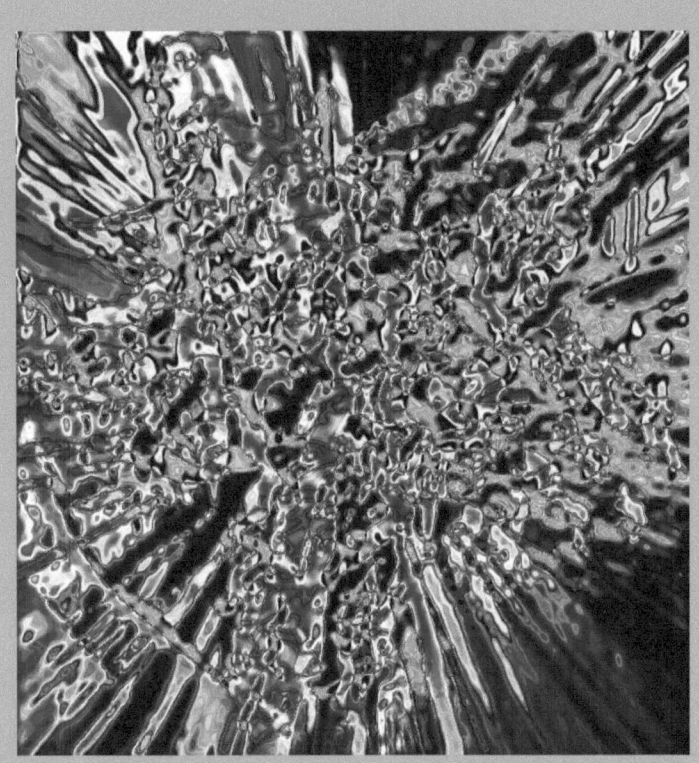

Genres:
Post-bop
Electronic Jazz
Hip-hop Jazz
Crossover Jazz
NuJazz
Jazztronica
Free Improvisational
Electronica

Highlighted Albums:
BBNG (2011)
III (2014)

Collaborators:
Tyler, the Creator
Odd Future
Frank Ocean
Danny Brown
Ghostface Killah

Trivia/Facts:
BADBADNOTGOOD is also known as BBNG
BBNG has charted on both the Jazz and the Electronic Music charts in the US
BBNG is a Toronto based jazz trio
BBNG played six sets as the band in residence at the 2012 Coachella Valley Music and Arts Festival. They as acted as Frank Ocean's backing band at the festival.

BADBADNOTGOOD

Antônio Carlos Jobim

Genres:
Bossa Nova
Latin Jazz
Brazilian Jazz
Samba

Highlighted Albums:
Getz/Gilberto featuring Antonio Carlos Jobim (1963)
The Wonderful World of Antonio Carlos Jobim (1965)
Wave (1967)
Frances Albert Sinatra and Antonio Carlos Jobim (1967)
Stone Flower (1971)

Primary Instruments:
Piano
Guitar

Primary Collaborators:
Stan Getz
Joao Gilberto
Astrud Gilberto
Frank Sinatra
Sergio Mendes

Trivia/Facts:
Jobim is noted as an early developer of the Bossa Nova sound.
ACJ first came to worldwide prominence in 1864 when the song
"The Girl From Ipanema" became a hit. He co-wrote the song with
Vinicius de Moraes (Norman Gimbel translated the lyrics to English).
The 1964 album "Getz/Gilberto" won 3 Grammy Awards including Album of the Year
"The Girl From Ipanema" won the Grammy Award for Record of the Year
His last recorded album 1994's "Antonio Brasileiro" won a Grammy Award
for Best Latin Jazz Performance
Antonio Carlos Jobim posthumously won a Lifetime Achievement Award in 2012

Antônio Carlos Jobim

Thievery Corporation

Genres:
Chillout
Lounge
Acid Jazz
Downtempo
Downbeat
Trip Hop
Electronica

Highlighted Albums:
Sounds From the Verve Hi-Fi (2001)
The Richest Man In Babylon (2002)
Cosmic Game (2005)
Radio Retaliation (2008)
Culture of Fear (2011)
Saudade (2014)

Collaborators:
Bebel Gilberto
Stevie Wonder
Anoushka Shankar (Norah Jones' sister)
Chuck Brown

Trivia/Facts:
Each of their albums feature various vocalists including Bebel Gilberto, Pam Bricker, LouLou Ghelichkhani, Mr. Lif, Natalia Clavier and others.
Thievery Collection was formed in Washington DC in 1995
They were the opening act for Sir Paul McCartney in 2009 at the FedEx Field in Maryland.
Their music oftentimes became political defining their progressive views. Their albums "Cosmic Game" and "Richest Man In Babylon" directly displayed their disapproval of George W. Bush's policies.
Thievery Corporation has placed eight albums in the Top Ten of the US Electronic Albums chart.

Thievery Corporation

John Coltrane

Genres:
Free Jazz
Avant-garde jazz
Hard Bop
Post-Bop
Modal Music

Highlighted Albums:
Coltrane (1957)(Prestige)
Blue Train (1957)
Giant Steps (1960)
Coltrane Jazz (1961)
Impressions (1963)
Coltrane (1962) (Impulse)
A Love Supreme (1965)
Expression (1967)

Collaborators:
Dizzie Gillespie
Thelonious Monk
Mile Davis
Cannonball Adderly
McCoy Tyner
Eric Dolphy
Alice Coltrane
Duke Ellington
Freddie Hubbard
Milt Jackson

Nickname:
Trane

Trivia/Facts:
After his death, John Coltrane, was canonized by the African Orthodox church as Saint John William Coltrane. In 2007 he was given a posthumous Pulitzer Prize for his "masterful improvisation, supreme musicianship and iconic centrality to the history of jazz."
Coltrane's earliest musical development came when he watched Charlie Parker perform in 1945.
Coltrane performed with the Miles Davis Quintet in 1956 resulting in the albums, "Cookin'," "Relaxin'," "Workin'" and "Steamin'."
Coltrane worked with Thelonious Monk in 1957 birthing "Monk Himself" and "Monk's Music."
Coltrane worked with Miles Davis from 1958 to 1960 and appears in the classic albums "Milestones" and "Kind of Blue."
John Coltrane died from liver cancer in 1947 at the age of 40.
John Coltrane was awarded a posthumous Grammy Award in 1982 for Best Jazz Solo Performance in the album "Bye Bye Blackbird." He was awarded the Grammy Lifetime Achievement Award in 1997.

John Coltrane

Miles Davis

Genres:
Bop, Hard Bop, Post Bop
Jazz-Funk, Jazz-Rock, Fusion
Cool Jazz
Modal Music

Highlighted Albums:
Blue Moods (1955)
Walkin' (1957) / Cookin' (1957) / Relaxin' (1958) / Workin' (1959) / Steamin' (1961)
Miles Ahead (1957) / Milestones (1958)
Porgy & Bess (1959) / Kind of Blue (1959)
Sketches of Spain (1960) / Seven Steps to Heaven (1963)
Miles Smiles (1967) / Bitches Brew (1970)
Jack Johnson (1971) / Tutu (1986)

Primary Instrument:
Trumpet

Collaborators:
Billy Eckstine / Dizzie Gillespie
Charlie Parker / Thelonious Monk
Charles Mingus / Bill Barber
Max Roach / Bill Evans
Hank Mobley / Herbie Hancock
Wayne Shorter / Dave Holland
Chick Corea / Jack DeJohnette
John Scofield / George Duke
Quincy Jones

Nickname:
The Prince of Darkness

Trivia/Facts:
Miles was given the nickname "The Prince of Darkness," due to his dark and brooding persona on stage.
"Kind Of Blue," which has sold more than four million copies in the US, is the best selling jazz album of all-time.
"Kind of Blue" has been certified 4x Platinum in the US
"Bitches Brew" has been certified Platinum and "Sketches of Spain" Gold.
Miles has won nine Grammy Awards
Miles Davis has been involved in almost every important development and progression of jazz music from the 1940's through the 1990's. Miles Davis is considered one of the most influential musicians of all-time in any genre of music.

Miles Davis

A Rick Henry Production 2016

www.ingramcontent.com/pod-product-compliance
Lightning Source LLC
Chambersburg PA
CBHW050901180526
45159CB00007B/2756